The Ins and Outs of Movies:

A general analysis of movies

The Ins and Outs of Movies

Contents

1. Introduction

2. Movies at the Cinemas

3. Making a Movie

4. Effects of a Movie

5. Movie Makers – Producers through to Directors

6. Stars in a Movie

7. Audiences of a Movie

8. Conclusion

1. Introduction

Television and Movies have had a profound effect on people, lifestyle and society in general, for good and for bad. Ranu on Urch.com (30 September 2002) commented how the *"latest phenomenon that has been observed is that of life being influenced by movies or television."* There have been many films made over the years of different variety with some epic and spectacular and some quite ordinary or poor. Either way, they have had an influence on us in some way or another. For those who watch movies, either occasionally or frequently, each of us has different likes and dislikes, for example action and drama compared to instructional and documentaries. There is a big effort involved from people behind-the-scenes to get a film to air in the various forms, such as cinema and television. It is like the stars or participants in making movies live in another world to us, and us people are looking from the outside in, which in a way makes it all the more entertaining and interesting in one way; alternatively we tell ourselves we don't want to or will never be like these stars. Some people are persuaded to copy some of these films in our lives, which can be positive or negative, for example learning from a documentary or mimicking action star James Bond 007 or drama Days of our Lives, which can be quite risky. One thing people would like to know about movies is are they real or not? It would have to be some quality stunt work to carry out some of these moves, situations, talk and expressions from actors and actresses.

2. Movies at the Cinema

Cinema is part of an international marketplace characterised by a cross-border flow of talent and a global circuit of festivals and awards. There is a *"geographical divide between big film producing countries which dominate global cinema production and consumption and the smaller, but still vibrant, markets for domestic films."* (UNESCO, February 2012) There are international co-productions in some regions, meaning 'national cinema' no longer applies in these cases. UNESCO highlights this in its statistics for movies in 2007 to 2008 discussed later in this paragraph. Movies can pass many boundaries, like some other things in the global society – geographical, cultural, social, political and economical.

While most countries rely on their domestic film scene, some countries and continents continue to be transnational with regards to the influence of their film, namely America and North America and India and South Asia. This was shown in United Nations Educational, Scientific and Cultural Organisation's (UNESCO) Institute for Statistics results for the Top 20 movies from around the world for 2007 and 2008. Three quarters were from the USA or the USA combined with some other countries (transnational), with Great Britain, Germany and Czech Republic surfacing on a minimal level. The surprise was that India or South Asia not coming up at all. Despite this, there was a *"rapid drop in scores for films in the No.20 position, indicating a level of diversity in audience preference"* (UNESCO, February, 2012). In this sense, for the current time period, there is no true allegiance to movies with so many circulating and the viewer being more knowledgeable and discerned.

Throughout the world, the major countries were obviously shown to produce more films, from 2005 to 2009. Here is a listing of these countries from UNESCO, February 2012 - Egypt, Morocco, Lebanon, Tunisia, Armenia, Azerbaijan, East and South Asia with India, Japan, China; Australia, New Zealand, Brazil, Chile, Argentina, Mexico, Russia, Turkey, Burkina Faso, Cameroon, Nigeria and South Africa. According to Statista, the film industry generated 464 billion U.S. dollars in revenue in 2011, despite a decline that year in revenue, but will grow a further 5.2% over the next four years. Cinema sites have been falling as well with 7,800 in 1996 to 5,700 in 2011. Ticket prices were reduced in 2012 to bring back larger audiences. Warner Bros produced the most movies in 2011 but Paramount held the biggest market share and revenues.

The movies that seemed to do the best at the box office were mainly, action, comedy, animation and some drama, as highlighted by UNESCO's Top 20 movies worldwide for 2007 and 2008. An Action movie will give you the influence of violence, fighting, murders, cheating, theft and bringing failure of one's plans (Blurtit.com). Of course this was predominantly from the USA. Pirates of the Caribbean got the number 1 movie in 2007 and Kung Fu Panda was first in 2008. These movies support the young male generational bracket that enjoy and thrive on this. Over the past 10 years, the highest grossing movies at the box office worldwide were Avatar, Titanic, Marvel's The Avengers, Harry Potter,

Transformers and The Lord of the Rings, in this order (Box Office Mojo). Amazingly, these are all fictional action movies, just what the younger males want. Independent films take risks with content and structure as well as cinematography and are less likely to get financial support they need to ever see the light of day (brettd, July 14, 2011, Enotes.com).

As mentioned later on in this report, more movies need to be made for other ages and sexes like women and baby boomers. Some wives, single females or single mothers have time on their hands to sometimes watch a good movie, if available. Baby boomers, like our parents and grandparents of this era, grew up on movies, or films, when they first came out to the general public. There are many types of genres to analyse and cater to, with numerous ideas for a movie. However, movie makers know they have to satisfy their target market, especially for financial success and fame. Although satisfying a genre or style is important, and needs to be looked at more these days, some genres are 'done to the death' for the sake of financial interest to keep the big conglomerates earning (kiwi, July 16, 2011, enotes.com). Examples are vampires and wizards and reality mockumentaries.

Additionally, with these ideas comes a need to control what is made into a movie. Many of us have our views and needs and wants, but then again, there are always independent movies outside of the mainstream. Some viewers are ignorant, lazy or narrow-minded in not realising that if they do not see what satisfies them in mainstream commercial film, it does not necessarily mean that is it. There are many films outside of mainstream cinema that are just as good, if not sometimes better. Some people are used to an epic-style, quality theatre experience, regardless of the movie, that a mainstream theatre can provide. Independent cinemas like Palace and Dendy can be stereotypically regarded as less quality, smaller and less maintained as the mainstream theatres, although this is not the case.

3. Making a Movie

Movie watchers, or in other words, the audience, have the easy part to sit back and view a movie. Viewers around the world should acknowledge the hard work that goes into preparing and producing a movie or television program. The big budgets for some movies are justified with the large amount of various elements of the movie coming together to create the overall movie, for example, the script, the stunts, the talk, the expressions, the music, the themes and messages and special effects. The everyday population might criticize the people in a movie by stating it is a job like any other job. Some critics might go on to say that people in a movie have the best job in the world with their creativity, the money, stardom and fantastic men and women they meet. Either way, these people in movies are doing what they love and should be greatly acknowledged for the work they do in entertaining the general public around the world.

There are shows nowadays, like Entertainment Tonight on cable and The Movie Show on SBS in Australia that provide overviews of movies, including behind-the-scenes. It is questionable whether these overviews provide adequate and correct details of these movies, giving bias or properly critiquing the movie. Perhaps these types of programs are funded by these movie makers and stars and related groups, therefore creating bias, as each movie would want a favourable review. Viewers are smart and discerned these days and most have watched their fair number of movies and would therefore provide reviews and bias themselves, either in the comfort of their home in front of the television, in a newspaper column or on social networking and media on the Internet.

Some critics might say the budgets for some of these movies are too much. Such budgets may put considerable pressure to perform on stars in a role, or can corrupt the people of the movie with the negative side of having a fortune. This can be worse with a poor showing at the box office or on cable or DVD. Either way, the stars of the movie have usually done what they could to make the movie a success, or have they? There is always room for improvement and development and stars in movies, like the general population, can make mistakes. Then again, there is always editing. And is the crew behind making a movie as forgiving for mistakes from movie stars, especially big movie stars. As can be stated, big movie, big star, big money, big pressure.

With a big commercial movie geared for mainstream theatre comes the positive of generating employment. These big films involve a number of crew taking part in the various sections of a movie - pre-production, production and post production. For the subject of 'Filmmaking' under Wikipedia, it states that a film *"involves a large number of people, and can take from a few months to several years to complete"*. Imagine several years for a movie; it would be interesting to see what the cast and crew do all day. After all, it is only a 2-3 hour movie in general. But perhaps it is a part-time venture, or the special effects are quite involved and complicated. Everyone must work together for the movie to come together. With the widespread influence of movies, more people want to work behind-the-scenes, or as actors, as this can be fun and creative, but it requires specialized training and knowledge. Mohan (June 1, 2011) supports this, stating *"the movie industry has played a massive role in generating employment for people the world over. Since there are so many people involved in making and producing a movie, it naturally has a wide scope for new job openings."*

According to the subject of 'Filmmaking' under Wikipedia, in the *Pre-Production Phase*, every step of actually creating the film is carefully designed and planned. The production is storyboarded and visualised with the help of illustrators and concept artists. A budget is drawn up and insurance procured against accidents. The producer hires a crew and many Hollywood blockbusters employ a cast and crew of hundreds, while low-budget, independent films may be made with a skeleton crew of eight or nine, or fewer. In the *Production Phase*, video production/film is created and shot. More crew will be recruited at this stage, for example, property master, script supervisor and assistant directors. Shooting begins with the crew arriving on set at a certain time. Actors have their own call times for each set. Dressing and lighting can take many hours or even days and are often set in advance. The crew prepare their equipment, the actors are wardrobed in their costumes and attend hair and make-up departments, the actors rehearse the script and blocking with the director and the camera and sound crews rehearse with them. A take is over when the director calls 'cut' and camera and sound stop recording. In the *Post-Production Phase*, the video/film is assembled by the video/film editor. There is either entirely film or a mixture of film and video. This is the final stage where the film is released to cinemas or to consumer media. Press

kits, posters and other advertising materials are published and the film is advertised and promoted. The distributor and the production company share the profits.

Making a movie, according to Bowen, can be done using various software, like PowerDirector and Windows Live MovieMaker. Making a movie includes an initial story, idea, commission, scriptwriting, casting, shooting, editing, and screening the finished product before an audience that may result in a film release and exhibition. Making a movie involves learning the skills needed to create a visual text, or a short movie. You will learn the elements that go into making a movie. You will then be able to apply those skills to make your own movie that creates the meaning you want for your viewer. Make a movie involves *deciding what story to tell*. It can be fictional or non-fiction, or historical movie or children's movie. You'll need to look at what events are going to occur in the film and what the overall message is you want to convey. Then you have to *create a storyboard*. Once the idea for the film is there, take time to plan how each scene will progress. Draw some sketches for each scene. Plan what and how the actors will say, what costumes they will wear and props they will need.

Identify the Cast involves finding good quality actors for your movie as opposed to say finding an actor for a family reunion video. *Prepare your Resources* with costumes, props and sets maybe using a certain colour to stand out from the crowd. It is easy to forget the obvious and not-so-obvious props when making a film. You also want to consider whether you shoot a scene on location or if you create a set or background yourself. With *Filming, b*e sure to record a little more before and after each clip to work with the footage. Some things like audio can be removed and a voiceover, special effects and transitions and background music can be used instead. Have consistent lighting in the film so that the clips flow better when you are ready to combine them. With *Editing your Movie,* after you have taken the footage, you can combine it into a finished product. Video editing software can help trim and arrange clips, as well as make small adjustments in colour and brightness. Poorly filmed footage will make it difficult even for the most advanced video editing software.

The western world is stereotypically thought to be the biggest movie maker in the world. A children game-show in Australia called Double Dare, some years ago, asked the contestants the question, 'Who is the biggest movie maker in the World?'. A young male participant pressed the buzzer and blurted out, with reassurance, 'America'. But the host of the show said it was incorrect. The contestants dumbfounded, waited for the answer from the host, which was, 'India'. India, including the term they call, 'Bollywood', makes numerous movies for not only Hindu people to watch, but also for the general population. There are similar elements in Indian movies to movies from Hollywood for example, but with more or less drama, plenty of music and celebration such as interludes, and a good theme or message. People in Bollywood or India have thought of doing some movies or work in Australia, especially with so many people enjoying the movies. Others in Australia have Bollywood-type activities, stemming from Hindi movies. Event Cinemas in Australia were even showing some Hindi movies, along with the other popular Hollywood movies, for people to watch.

The question remains whether the stunts in a movie are real or not. Television shows like Entertainment Tonight and The Movie Show sometimes show the set for a particular movie with the stars going through a certain scene. However, when looking at the set, or stage, and then looking at the movie, one would think there is another place and time all together, as in another country or, realm. If it is specialist camera and computer and graphic design, it must be very good. In stating this, I would say the set or stage for a movie, as well as the stunts, are real, at least to quite an extent. This is quite a statement because some people think there are make-believe or imaginary settings, countries and backdrops, when in actual fact, in could all be real. There could well be use of divine, magical or supernatural power here to create and implement a real-life setting and scenes, for example, the old townships in Les Miserables or the high-tech futuristic cities, stunts and almost perfect human communications in some movies. A subject search on the Internet search engine Google brought up little or nothing on the subject.

Technology is a big word in cinematography these days with a number of movie makers as well as distributors. The United Nations Educational, Scientific and Cultural Organisation's (UNESCO) Institute for Statistics

states how *"major technological changes in the global film industry are altering patterns of production and consumption"* (February, 2012). In a bid for audiences and their money, *"film studios and cinemas are modernising their infrastructure to offer more and more exciting experiences"* (Statista.com). Special effects are the buzz words for today's films with unbelievable stunts such as The Matrix and James Bond 007 and technological advances like 3-D viewing with IMAX Theatres and movies like James Cameron's Avatar, which gave depth to the viewing and technology and so far is the highest grossing film of the past ten years. James Cameron thinks films will be bigger and sharper in 3-D. It is now a common thing to have 3-D in some movies, such as the animation movies. In 2011, *"45 3-D films were produced and shown on almost 13,700 3-D screens all over North America, compared to 26 3-D movies and 8,500 screens a year earlier"* (Statista.com). Technology has previewed a lot in recent movies with touch screens on computers and flying cars. Direction that technology will take is sometimes reflected in films.

The problem with films is that most are viewed away from traditional cinemas with the rise of 'transmedia' across print, film, web-based, video/DVD and television (UNESCO, February 2012). With regards to viewing a movie, digital and high definition televisions at home have transformed viewing, with most people now owning a widescreen plasma television instead of conventional square, bubble-tubed screens. These screens, like other forms of viewing as projector screens, Internet, DVD and video, have affected movies at cinemas. iuli from Urch.com (16 June, 2003) states how this technology affects our social circles – *"instead we prefer watching a movie at home and this definitely does not help broadening our social circles."* Then again, as iuli from Urch.com states, not watching television or movies can keep certain viewers away from important news or pieces of vital information and facts on life. Mohan (June 1, 2011) support this by stating how with the *"advent of newer technology, the number of theatre goers has reduced drastically, but the number of movie viewers has sky rocketed".*

Since the advent of DV technology, this means production of an independent movie has become democratised ('Filmmaking', Wikipedia). Filmmakers can shoot and edit a film on a home computer. Despite this democratisation, financing, traditional distribution and marketing are

difficult to accomplish outside the traditional system. Most independent filmmakers have relied on film festivals to get their films noticed. But now there is the Internet, allowing for inexpensive distribution reaching global audiences, especially through several mainstream Internet companies.

Swaim (November 30, 2012) states how making an independent or any movie at that, unless a big budget one, has some points to consider. One, don't set the movie at night otherwise you have to use giant red-hot lamps on impossible tall metal rods. Secondly, don't use a giant ensemble, unless you are a big budget film. A small stage and some characters would be of help, otherwise you have to fly your movie stars to locations, house, feed and keep them safe and entertained. Watch out for on-set accident bloopers, like crashing a van through a wall, as this can be messy to clean up and costly to the wall, in this instance, which was damaged.

4. Effects of a Movie

This is probably the most important part of the report, in that it is the effect of a movie on its audience that is significant. A movie has the biggest effect on the general population who are viewing the movie. Mohan (June 1, 2011) makes the point that *"movies have become such an inseparable part of our lives, that it is tough to imagine a world without this form of entertainment"*. Mwestwood from Enotes.com (July 12, 2011) explains how 'movies imitate life' and 'life imitates movies'. It can probably be said that movies imitate life more so as society produces the context which makes certain films popular. Examples of this are 'The Hurt Locker' showing the involvement of Western nations in Afghanistan and Iraq, and 'Traffic', showing the social realities of the flow of drugs between Mexico and the USA (accessteacher, July 13, 2011, Enotes.com). Whereas art, i.e. the movie, has no limits in its application, life itself has more limits. Taking this point, life can therefore imitate movies with a person's or groups aim to reach or go beyond the limits.

There are some great movies out there, and there are some poor ones. Overall, movies provide social entertainment, usually to the benefit of the person. Mohan (June 1, 2011) states how *"movies act as an escape hatch for people who wish to forget about all their worries, frustrations and tensions of their private and public lives, even if its effects last for a few hours"*. But everyone's view is different with regards to a movie. Some

people watch movies very seldom, some watch movies all the time. For example, some viewers enjoy the weekend evening movie with the family or wife or husband. This makes the movie all the more special because it is an indulgence or special treat. Some people have cable television, with a plethora of channels, i.e. movie channels, and watch this often during the week and on the weekend, or go to the cinemas frequently.

On one hand, the enthusiastic movie-goer who loves movies can have a great indulgence and watch a great variety of movies to feel comfortable. Some viewers can even use the movies as a form of therapy, relaxation and survival skills. Conversely, there is a chance, if not risk, of getting bored of these movies as there are a lot of them or it is frequent. The viewer's senses may become dulled and they may even become influenced by the movies acting parts out in real life to some extent. As the saying goes, 'everything in balance' and 'too much or less of something is not right' relevant to the individual. Ranu from Urch.com (30 September 2002) supports this by stating *"excess of everything is bad. Therefore too much television and movies is also bad for us, and this is especially in reference to 'couch-potatoes' and 'movie-buffs'."* People have made songs, stories and talks about the effects of things like movies on people, including technology, for good and bad, or neutral, and of course there are other things too.

In fact, movies, like information, are all around us in today's society. Mohan (June 1, 2011) highlights how films can give a reality check to some viewers, depending on the genre, and this can be a positive thing. Some films increase our awareness through arousing responsibility, empathy and assistance and our thought processes, imagination and creativity about certain issues affecting people, society and the world, such as socio-economic and political. Historical and political movies inform us about the great empires like the Chinese and Romans, as well as Cultural movies on religions, arts, literatures and traditions. Some movies about gangsters and people of the Roaring Twenties were glamorized in this era, as well as liberal thinking towards certain ethnic groups in the 1950's and 1960's, for example, 'Guess Who's Coming to Dinner?' with Sidney Poitier and Katherine Hepburn. These movies have stories about people who made great sacrifices for their noble ideas, such

as Abraham Lincoln and Kamal Ataturk, thus teaching people the importance of struggle for success.

After watching a positive movie, viewers may think about actually doing something but may never do it. There have been some cases where people have supported or taken up a case based on the influence of a film, such as animal protection and human rights. Ranu from Urch.com (30 September 2002) states how these days, the world's democratic nations are using this media to create awareness and also as a link between the government and common man. Ranu gives an example of the *"government election process in 'Kashmir, India' being closely monitored to convince people about its transparency and increase their faith in their elected government".* Unfortunately, as iuli from Urch.com (16 June, 2003) states, there is still dictatorship in the world where the television in the country must obey what the government wants or does not want to broadcast, leading to manipulation to some extent.

It can be difficult to try and avoid being exposed to movies in various ways, for example, advertising on billboards, on television, the Internet. Films are made for the purpose of making money and therefore they have to reflect what people want (pohnpei397, July 13, 2011, Enotes.com). Mohan (June 1, 2011) acknowledges how we need advertising to find out about movies and television programs because *"movies can successfully influence their viewers' curiosity and interest to a very large extent. It takes a few seconds of movie footage in order to market their products to the whole world."* People find out about the movie through the Internet and discussions with friends continuing the chain of advertising and communication. On one hand we find out about the movie through the advertising, on the other hand we have to put up with the consistency of contact and variety of advertising or may not like the quick attempt to catch our attention or the actual advertising because it does not show what is really in the movie.

There is sometimes an excess of things being shown in movies, like sex, drugs, violence and coarse language to name a few. This could, at some point, have an influence on a person and bring changes in people's behaviour towards each other, and there are often negative stories in the media where this has happened. Of lately, there have been numerous movies, films and documentaries about criminals, for example on the

National Geographic and Discovery Channels on cable television, presenting their crimes in attractive ways. The affect of movies, or television, is most profound in children and their mental development, health, conversation with adults and interaction with other children (Comeondesis.com, January 27, 2009). Children get attracted to and try to imitate the interesting characters in a film. With the change from old movies to new movies, where the old movies generally have a good theme, children are now being exposed at a young age to violence, criminals, murder, suicide and hitting a person.

Real positive heroes should be introduced to children, like those who protect our country (soldiers), serve the people (emergency crews) or who are ambitious and humourous (professionals). Positive activities need to be implemented like educational programs, playing games and reading. Children who grow up in families with film and TV spend less time reading, show less interest in spending time with family and are less likely to be able to read. Whereas children and teenagers talk about sports and games and the newest Hollywood movies, adults discuss about the world's political situation or social problems and in most cases they got this information from a television program or film (NJNJ.ru, 2008-2009).

Mohan (June 1, 2011) states how movies affect viewers' lifestyle, *"everything we watch and listen to affects and influences us at some level or the other"*. Viewers try to copy actors in a movie, with fashion trends, the way they speak and the lifestyles they lead both on and off the screen, which can be beneficial and fun or detrimental. ditoman from Urch.com (12 February 2004) calls this 'imitation psychology'. People want to be interesting and famous like how some females used to die their hair blond to mimic popular American singer-actress Marilin Monroe. There was also the 1967 movie Bonnie and Clyde influencing women's styles. Then there was the 'Flower Power' and 'Hippies' of the 1970's (Erin, 23 September 2002, Urch.com). In India, a boy who lived in Gwangju set a fire in a neighbour's house a few years ago. When questioned by police who asked him why he ignited the fire, he just said he saw it in a movie (ditoman, Urch.com). There are certain phrases uttered by famous actors that have become buzz words and catch phrases in American culture, like 'here's looking at you kid' from 1942's Casablanca and 'I'll be back' and 'Hasta la vista baby' from The Terminator and Arnold Schwarzenegger.

Movies have to complete a story in a short span of 2 hours. This constraint means movies are loaded with lots of exaggerated emotion, drama, action and comedy (Ranu, 30 September, 2002, Urch.com). The affect on the body is obvious with Ranu explaining how the sudden change in emotions in a movie *"has an adverse effect on human mind leading to depression and related disorders".*

Contemporary movies show all sorts of activities considered bad or evil by everyday society. From a negative point of view, movies influence people by affecting moral beliefs and practices. Mohan (June 1, 2011) states how some movies for instance have *"seriously jeopardised the very foundation of marriage and faith in God",* suggesting incorrect relationships that are extremely unsafe and detrimental for everyone involved. In Hindi movies, the Tamil culture for example respects women as mothers and sisters. This belief has been attacked by the present Tamil movies. Former Tamil movies had women characters fully covered with their sarees. Nowadays, women in Tamil movies show too many things and some political parties made a big scene about how the Tamil culture was badly affected by such movies (Gokulkrishnan, R.C. June 14, 2007). Nowadays, according to akhan from Urch.com (12 February, 2004), there are programs and documentaries on women like 'Today's Woman' and 'Woman's right in the eastern world' that have improved women's rights and has changed the way women were treated 40 or 50 years ago.

Bollywood has had an immense impact on people's and actors lives in the region and elsewhere, becoming a family culture. Social media, YouTube, mobiles and computers have some sort of Bollywood activity (Museum of the City.org). Some see the Bollywood films and want to take part in one, so states Bollywood model-actress Aamina Sheikh who has received acknowledgement and awards for her work (Dawn.com, 25 October, 2012). A number of model-actresses of Bollywood have won some sort of award or pagent, whether it be Miss India, Miss World, Miss Universe or Miss Asia Pacific. A number of youth try to look as beautiful and glamorous as these actresses. Indian culture is turning towards fashion and imitation on television and the big screen (Darshana A, January 20, 2009). Bollywood movies are produced with low moral values nowadays showcasing westernised culture and Hollywood, with actors for instance consuming liquors and cigarettes, undermining patriotic values, fighting

and wearing easily seen clothing. Most people in Bollywood's region don't like the actions, stunts and eroticism but prefer instead the funny and family based motion pictures. Bollywood producers, story writers and directors need to promote good ideas, social awareness and good culture. The songs are not a bad thing, for example the interludes, and also the theme of love and extravagant music and fashion. The cities of Mumbai and Delhi have been influenced a lot. Some good Bollywood movies have been made with the Legend of Bhagat Singh, Hey Ram, Hera Pheri, Golmaal, Chakde India and Taare Zameen Par.

One might say to keep away from it if a person is not interested, but the problem is there are those in society who knowingly and unknowingly push movies, amongst other things, into people's viewing and experiences. An example is the amount of advertising everywhere for Hollywood movies but not independent movies. A deal of control is needed here, and this may be obvious, but people in society have acknowledged how it has increased, and therefore it may be a matter of time before some influence can happen. Some spiritual and or religious belief; support from information, individuals and groups; and personal development can help these people stay clear of such negative influences from movies.

In stating this, it is what we expose ourselves to, with certain regards to movies and television programs, that is important. People are different and some want to focus on other factors of their lives other than movies or television programs, for example, work and education, health and exercise, spiritual and religious belief and relationships with people. Therefore movies are an indulgence, like the weekend evening movie mentioned earlier. A good option is watching more constructive movies and programs like comedies, romances, overcoming bad or evil, biographies, reality television and documentaries as examples. People are entertained, have fun and learn and grow from these positive types of movies and television programs.

However, and this has to be stated to explain those who do like contemporary movies, from example Hollywood and Bollywood, that they occasionally or often enjoy watching movies and television programs and their negative view of life. Some people even thrive on it, assured in themselves that they can withstand viewing the negative or bad side of

movies and television programs. For example, some females like watching television drama shows such as Days of our Lives and Bold and the Beautiful, whether working and or at home with the children. These programs provide entertainment and something different from the normal situation of life, like romance and conversations and communication. Some males like action movies such as James Bond 007 or Arnold Schwarzenegger, again for entertainment and some variety from the normal situation of life, but also to reinforce their manhood and active lifestyles. Again, the person needs to look at themselves if they can withstand watching a movie or television program like these, according to their personality and character, as a male or female, or if their mind, body and spirit are consistently strong enough to view, experience and analyse correctly.

5. Movie Makers

There have been some unbelievable movie makers throughout the years, producing and directing various initiatives, like all the epic movies of yesteryear, for example Kings and Queens and battles and the Roman empire amongst others, country and western movies, religious, romance, and so on. It would be quite difficult and competitive, and in stating so, unfair, to rate who is the best movie maker of all time as there are many movies and genres. Some names are Steven Spielberg (Back to the Future trilogy), Alfred Hitchcock (The Birds), Peter Jackson (Lord of the Rings trilogy), Rodgers & Hammerstein (Oklahoma, The King and I and The Sound of Music), Andrew Lloyd-Webber (Jesus Christ Superstar, The Phantom of the Opera, The Wizard of Oz) and Albert R. Broccoli and Harry Saltzman (James Bond 007 series). Some people like the movies of old, stating they are better actors and actresses and better movies overall compared to those of today. Some like the movies of today.

Some famous Directors are Ron Howard (Happy Days/Cocoon/Apollo13), Francis Ford Coppola (The Godfather/Dracula), George Lucas (Star Wars trilogy), Ridley Scott (Alien trilogy), Martin Scorsese (Gangs of New York, Taxi Driver, Raging Bull), David Lynch (Blue Velvet, Lost Highway, Mulholland Drive) and Larry and Andy Wachowski (Matrix trilogy). Some famous Producers are Jerry Bruckheimer, arguably the most successful ever with his projects grossing over $11 billion. Some of his movies are

Flashdance, Beverly Hills Cop, Top Gun, Bad Boys, The Rock, Armageddon. Next is Brian Grazer, a prolific producer who has made over 100 movies and television shows. Some of his movies are Splash, Parenthood, Kindergarten Cop, Backdraft, My Girl, The Nutty Professor and Liar Liar. Frank Marshall did not really become famous until the Indiana Jones trilogy. Other movies of Marshall's are The Goonies, Back to the Future trilogy, The Colour Purple and Who Framed Roger Rabbit. Lastly, Avi Arad is the CEO and President of Marvel Studios, the entertainment division of Marvel Enterprises, the creators of Marvel Comics. Marvel was going broke until Avi turned the comic book hero Blade into a movie trilogy with Wesley Snipes. He has made a success out of other comic book heroes in the X-Men, Spider-Man, Daredevil, Hulk, Fantastic Four and Captain America (Fulks, lovetoknow.com - Movies).

Movie makers receive awards too like the stars at a number of ceremonies, but each play a part in having a movie come to fruition. Movie makers can come from various backgrounds, for example, writing and literature, drama, philosophy, sports and exercise, etc. With the broad reach of movies, people from different backgrounds, even no background, can make a movie. Some take hours, whilst others take years to make a script as well as their work on stage, stunts, graphic design and special effects. One may ask what makes popular and big movie makers the way they are. There is first the love to entertain people, then the love of movies and then the love of career and personal development. This may sound obvious to some but in general terms, this is usually the case. The best movie maker is the one who has a great idea and puts it into action. They take the time, however short or long, to think each scene through, including all that is involved, and then experiencing the sensory extravaganza of it all coming together.

6. Stars in a Movie

The 1920's saw Hollywood film company promoters create 'fame' and brand loyalty for its actors and actresses (Wikipedia, Movie Star). People from the sports and entertainment and socialite fields were mainly seen as celebrities. There was various true and made-up tactics to attract fame to stars, with press releases, publicity, movie junkets, community activities, real or fictitious biographical information, gimmicks and

orchestrated events. This created a pervasive, contemporary, celebrity culture where fame became a massive industrial enterprise and part of a broader social process connected to widespread economic, political, technological and cultural developments. Screen legends were made in Judy Garland, Rock Hudson, Marilyn Monroe and Grace Kelly. However, getting the fame was one thing, keeping, maintaining and furthering the fame was another thing, with movie stars having to endure all the successes and joy and trials and tribulations that came with fame. Examples are becoming a recluse, being security conscious, being the object of gossip, people's cruel jokes and target of sheer hatred (Chapati, April 4, 2009). Once a movie star, now a celebrity linked with fame and fortune that attract a great degree of public fascination and influence ('Celebrity' Wikipedia,).

Bollywood also has its fair share of movie stars, who fans follow almost like mini-gods, and command high pay in line with their box office appeal. Shahrukh Khan is probably one of the most popular and powerful Bollywood stars in the world, regarded as the King of Bollywood. He has, not millions, but billions of fans and a net worth of Rs 2500 crore, or $540 million. He has received the most awards and out of the 10 biggest movie hits in Bollywood, he as 7 of them ('Movie star', Wikipedia). There are many other Bollywood stars close behind. China has also produced some big name stars in Eastern Asia and the western world with Jackie Chan, Jet Li, Chow Yun-Fat, Stephen Chow, Maggie Cheung, and the late Bruce Lee.

There have been some childhood stars who have seen fame and fortune and then burnout. Success is great when they have it, but the drop from success can be big, with some stars falling into substance abuse, bankruptcy, personal and family problems and losing faith spiritually and religiously. There are some examples of how too much fame too quickly and too young can have detrimental effects on a not-so-aged personality. Morgan (MSN Movie News) states how some stars *"have crawled out of a rut, some have died and some have remained in the notorious files"*. These stars are the Olsen sisters, Mary-Kate and Ashley, Corey Feldmen, Drew Barrymore, Scott Baio, Tatum O'Neal and the Different Strokes cast.

There are some top movie stars in America who play the big roles and ask the big pay checks. Squidoo.com, Rihan on Listal.com (30 September 2010) and Big Brothers on gettoptens.com (April 6, 2012) has made a list of the Top Most Famous Hollywood Actors and Actresses. For the Actors there is Tom Hanks, Johnny Depp, Tom Cruise, Robin Williams, Jim Carrey, Will Smith, Leonardo DiCaprio, Sylvestor Stallone, Antonio Banderas, Orlando Bloom, Charlie Chaplin, Kevin Costner, Sean Connery, Matt Damon, Michael Douglas, Robert Duvall, Clint Eastwood, Harrison Ford, Richard Gere, Mel Gibson, Gene Hackman, Eddie Murphy, Jack Nicholson, Al Pacino, Gregory Peck, Tommy Lee Jones, Keanu Reeves, Christian Slater, Patrick Swayze, John Travolta, Jean-Claude Van Damme, Bruce Willis, Pierce Brosnan, Colin Firth, Nicholas Cage and Russel Crowe. For the Actresses, it is Angelina Jolie, Jennifer Aniston, Meryl Streep, Sarah Jessica Parker, Cameron Diaz, Sandra Bullock, Reese Witherspoon, Nicole Kidman, Drew Barrymore, Renee Zellweger, Natalie Portman, Keira Knightley, Rachel McAdams, Halle Berry, Jessica Alba and Penelope Cruz.

A movie maker does have a tough task thinking of and putting the movie together. However, the stars of the movies also have a difficult task of fulfilling their roles as they are doing it in action, or in real life. Most actors love what they do, finding that movies help boost their imagination. Mohan (June 1, 2011) summarizes it perfectly with *"young aspiring actors and movie makers are desirous of joining the movie industry, simply because they too will get to explore new horizons of their creativity and produce something new and awe-inspiring"*. Actors read and learn the scripts and then go about carrying out the script according to how the movie makers want or need it done.

Some actors and actresses are that talented, or have experience of a lot of movies, that they contribute to assisting movie makers in producing through to directing the movie being made, for example adding certain lines of scripts and expressions, such as Arnold Schwarzenegger's 'I'll be back' or Nicolas Cage's expressions and actions of excitement. Ben Stiller, one of the world's biggest comedic movie stars with movies like Something About Mary and Meet the Parents, takes full responsibility for a film, even though he's just an actor, working at ground zero in modern comedy as he loves to direct. His directing sometimes brings films over

budget and movie makers prefer him to act than direct, but that does not take away his skill in directing. He goes from *"retooling the script to approving the director, assembling the cast and overseeing how the scenes are edited together."* (The New Yorker, 25 June, 2012). Ben Stiller created the way modern sketch shows are shot, but he never intended on being a movie star. Other movie stars have taken the next step and made a movie, or movies, themselves, for example, John Travolta and Phenomenon and Mel Gibson and Braveheart. The big stars get the big salaries for helping to make the movies.

The negative effects and circumstances of some actors and actresses falling victim to the influence of movies and movie-making should not be made common for all actors and actresses. Some if not most movie stars have had positive and fruitful experiences of being in the movie scene. Most movie stars want to make movies for the love of it, sometimes the fame and fortune. This sincere love for making a movie should not be lost and must be cherished and protected. It is interesting to note how as the quality of movies has dropped, so has the quality and strength of movie stars. There is almost a cheapening of movies as more movies are being created and the good movies sometimes get lost in amongst the bad ones. Some would argue this, as there have been some great movies and great stars in recent years and this is definitely true.

It is only of lately that the effects of movies have been affecting movie stars in a negative way. The pressure to perform and more the fame and fortune side of things have caused problems for movie stars, for example, drinking and substance abuse, media attention, broken relationships, taking their lives, accidents, gambling and living life on the edge. There are many examples of movie stars who have experienced these sorts of things. One could say making a movie these days, if not a big movie, is almost like a trap because once you have done it, you may have society chasing you for some time after and your privacy may be affected. An example of this is the huge publicity and promotion for the movie stars of the vampire-werewolf film 'Twilight'. It is amazing these stars are still alive after all that. However, most movie stars are aware of this when making a movie and would have been taught to handle it by their managers, movie makers and movie companies and family and friends. Then again there

are stars that have gone into movies blindly and have experienced a make or break scenario in their lives.

It would be interesting to compare movie stars from Hollywood to those in Bollywood and other B grade and cultural movies. Some famous Bollywood stars also receive the star treatment in their own countries. There would definitely be some of these Bollywood stars who have fallen to the effects of making a movie and their fame and fortune. Bollywood actors though have more of a respect for themselves compared to those in Hollywood. This has also come from their cultural and moral and religious upbringing. This of course is a generalisation, and it can work both ways. This is the same with cultural movie stars who would be famous in their own country, but also overseas on a quiet level with culturally-rich movies and television programs on media like SBS in Australia, DVDs and movie festivals. B grade movies are for movie actors and actresses who concentrate on their love for movies rather than the fame and fortune, going for quality rather than mass production. There are many good B grade movies that have gone unnoticed, including their stars, and intend to continue to do so.

Some individuals and movie stars have come from film-making, drama and theatre schools, which stereotypically most are said to have come from. This would make an interesting transition into movie-making. Actors and actresses from drama and theatre schools can make good movie stars because they have had the preparation and real-life practice that some others did not have. There are some people who study in the area of film-making and do it as a side interest, as a sub-major at university, TAFE or private college. Those who make film-making a major area of study are those who want to do B grade films and keep it all quiet, want to make it in the local movie scene, or, in Hollywood or Bollywood. Sylvestor Stallone, for example, did the script for the famous movie of Rocky in about one hour.

7. Audiences of a Movie

Obviously it is important to take note of the effect of movies on audiences. But it is also important to acknowledge the audiences themselves because without the audience of a movie the movie would be worthless, and the time and effort would have gone to waste. In stating this, there will be a look at the ins and outs of audiences to a movie, for example demographics and attitudes and the like.

When someone states the word 'movies' these days, they stereotypically think Hollywood and Bollywood and young people. Movie viewers have to be smart in today's society in sifting through the surface of mainstream movie advertising and shows about movies to find the movie they are looking for or to choose from a hidden wide selection of good movies. Audiences are accustomed to movies more so than in previous years so they would be aware of independent or B grade films on television stations like SBS and ABC in Australia, movie channels on cable television and independent cinemas in Australia like Palace, Dendy and Ensemble Cinemas and IMAX Theatre.

With today's fast and busy lifestyle, there are audiences who watch television and movies and those who don't. Working couples and families might watch the evening news, sports highlights, a documentary and perhaps the odd movie from time-to-time whereas wives or husbands at home, single mothers, young couples, students and school children, migrants and refugees might watch more movies with more time and energy on their hands. This is of course is a generalisation and may be different when these groups are looked at specifically, for example a person's or group's interest in a specific genre or in movies in general.

Statistics show that young people, or youth, are the target market of most Hollywood and Bollywood movies, although this is changing to incorporate the older age groups. It is usually young males 12 to 34 that frequent a movie cinema nowadays. SAWA states how the cinema audience is attractive (affluent and young), avid shoppers into fashion and technology, lead busy and active lives and have good education levels. The young age group recall more of advertising and the film at the cinemas than any other medium. People aged 18 to 24 bought an average of seven tickets per person in 2010 in America down from eight in 2009 (Barnes and

Cieply). In 2010, *"North Americans aged 12 to 24 made up only 18% of the population but bought 32% of the 1.34 billion tickets sold"*. The genres that currently dominate Hollywood are *"action, raunchy, comedy, game/toy/ride/comic-book adaptations, horror, all aimed at ADD (Attention Deficit Disorder)-addled, short-term memory lacking, easily excitable testosterone junkies" (Bryant C. January 5, 2012)*. How many more daughters, girlfriends, wives and female friends have to be dragged to sit through the above mentioned 'man-child' quadrant. It's near blasphemy for the women to ask a man to see a women-centred movie in return (Bryant C., January 5, 2012).

Women and Baby Boomers, or our parents and grandparents generations, are hardly seen at movie theatres compared to these young males, and are seen as niche audiences. However, things are changing with more movies now beginning to cater for these and other age groups. It is quite amazing being that some movie makers, i.e. scriptwriters and producers and directors, are Baby Boomers. Movie remakes made in the last 10 years have attracted an older age group and brought more people back to the movies. Women in general are not seen very often in movie making roles, or in few movies catered for women, except for some exceptions in movies. Bryant C. (January 5, 2012) states how *"there are few women directors, producers and writers in the industry and that the almost entire female demographic (under 25 and over) is practically invisible in the traditional film marketing equation"*. In 2010, women bought half of the total movie tickets sold and were 51% of the moviegoers. Barely 30% made up speaking roles in films. The female movie 'Bridesmaids', which was like a female version of the male film 'Hangover' had a large number of guys actually enjoy a chick movie. More women's films of this and other types are surfacing at mainstream cinemas.

It just shows how tailoring a movie to the needs and wants of a target market, like young males, is as important for the success of a movie and the film industry as a whole. But surely, some time and effort can be turned towards these groups, like Women and Baby Boomers, to get them back frequently into the cinemas. Barnes and Cieply (February 25, 2011) states how *"Hollywood has been slower to market to baby boomers, but is starting to get a glimpse of a graying future"*. It is good to get a change from the once-a-year over 50's audience. In 2010, the over 50 age group

made up 32% of the population, but compared to youth (32%) bought only 21% of the tickets. Despite this, this is an increase for the over 50's who bought 19% in 2009.

Older moviegoers has been up 67% in America since 1995 (Barnes and Cieply, February 25, 2011). The 78 million baby boomers in the USA have some leisure time to fill and have a dormant love affair with movies. Barnes and Cieply state how almost every movie studio has a movie aimed at the older audience on its current schedule or in development. Some movies have done really well with the 50-plus crowd with 'The King's Speech', 'The Social Network', 'Red', The Expendables', 'Dirty Old Men', 'Larry Crowne', 'The Best Exotic Marigold Hotel', 'The Fighter', 'Unknown' and 'Black Swan'. Black Swan sold over $100 million at the North American box office with the majority of the audience from the over 50's segment.

There is ageing action stars, theatres with adult fare, like better food, reserved seating, and movies that have become hits based on smart, compelling, witty and heartfelt storytelling and interesting characters rather than special effects (Barnes and Cieply/ 24/7/2012). The new James Bond 007 instalments are a good example of this, with some older viewers complaining how there was too much special effects and not enough story and dialogue. As theatre chains cut back on maintenance in their theatres this imbalance grew with young and old viewers. Sticky floors and popcorn strewn aisles, as well as the mobile phones and texting, have kept older viewers away from the movie theatre. Baby boomers have been "betrayed and abandoned" by Hollywood, and yet it was the baby boomers who were taking their children to the movies to watch films like the Home Alone series.

Cinemas have tried to reduce the price of movie tickets to entice cinemagoers back to, or to continue to go to the cinema (24 July, 2012). Prices of movie tickets used to be more expensive. Young people are used to paying these prices living a more affluent lifestyle but Baby Boomers and the older generation were brought up to watch their money, or pennies so to speak, and closely observe prices and price fluctuations in movie tickets. One thing can be agreed on, and that is if the movie is good, most age groups and sexes will pay the price for the ticket. This is something to take note of by movie makers because if there were more

movie, within consideration, catering for more people, this would not be the case as the movies will be good.

Food is also a factor with some older groups sick of loitered and sticky aisles, rude behaviour and mobile phones being used, mainly by young people. Some cinemas have tried to bring in healthy food snacks into the cinema food bar but had no success because most people stereotypically associated cinemas with snack and junk food as an escape and indulgence, like popcorn, ice-cream, soft drinks and lollies. Salon in America said that young moviegoers would pay an extra $7 for food, while the older generation would pay an extra $2 (24 July, 2012). However, with frequent moviegoers going to see a movie once every four weeks, consuming snacks can be overdone, and one would need to watch their health and weight. Additionally, and even better, the two major cinema theatres in America, Regal and AMC Entertainment have begun to include menus and fine dining and theatre-seat waiting and this has been a tremendous success for the older generations (Barnes and Cieply, February 25, 2011). The closest for this in Australia is Event Cinemas Gold Class or watching an independent film at a second-tier movie theatre-restaurant.

Cinema theatres have been transformed into state-of-the-art technology (24 July, 2012). There are surround-sound systems, 3-D viewing, comfortable individual seating, air conditioning and air fragrances. According to SAWA, the cinema is apparently the best method to catch the attention of young people because you will have their undivided attention for 2-3 hours. Cinemas have to compete with other forms of viewing, like television, Internet, DVD and video, to get moviegoers of various sorts to watch movies at the cinema. Good movies, and a variety of them, as mentioned a bit earlier, are what are required to further moviegoing.

Some, if not most film companies have put into place research on current and potential real publics of movies to see what and how they think to ensure financial investments pay off. Examples of this are surveys, focus groups and test markets and interviews and how they give rise to social discussion. Film Reference.com discusses how the film industry *"needs to bring in as many viewers as possible and therefore must keep close tabs on what types of stories will appeal to the greatest number of viewers*

at any given moment." What is found is that *"audiences shift over time in accordance with cultural tastes and trends" (Film Reference.com).*

Film audiences have changed throughout history. Film first was attracted by working-class and immigrant audiences who could afford a ticket at the theatre. In the 1910's film brought working class and middle classes together as one audience. In 1922, 40 million film tickets were sold per week and in 1929 90 million tickets were sold per week. The economic depression or Great Depression had audiences drop and many theatres close. World War II had a largely female audience with female film genres in the 1940's. After the war, the movie theatre had to compete with television. Hollywood had to rally, with 100 million tickets sold per week in 1946 but decreased in 1955 to 46 million. A trend to come out of this was teenagers who loved rock 'n roll with movies like 'Rebel without a Cause' (1955) and the 'Blackboard Jungle' (1955). With deregulation and the growing popularity of television meant the teenage audience was not enough to sustain the film industry in the 1960's. In the late 1960's the film audience were more young and sophisticated, with 48 per cent of the audience between 16 and 24 years in 1968, according to the Motion Picture Association of America (MPAA). Films like Easy Rider and Bonnie and Clyde (1967), Medium Cool, Midnight Cowboy and The Graduate (1967) were films this audience enjoyed.

The 1970's had Hollywood produce more independent and European-influenced films, like The Godfather (Francis Ford Coppola), Jaws (1976), Star Wars (1977) and Raiders of the Lost Ark (1981), despite being a financially-challenging period. Hollywood early on developed a system of self-regulation, for example the Production Code, to fend off government pressure and threats of censorship on its morally-challenging movies. It was 1968 when the MPAA established a ratings system for movies based on their age-appropriateness and remains the current system. PG rated films had financial possibility with audiences from multiple age groups where as R-rated films were seen as riskier. Following the success of the 1970's film blockbusters there was a change from the classical Hollywood model where an audience was found after a film's production, but instead pre-production market research and test screening involving quantitative and qualitative evaluations were carried out to ensure a film's audience demographics before its production. The studio may even order reshoots

to achieve what production executives think will be a more appealing movie.

8. Conclusion

Movies have proved to be a way of life in the global society, for good and bad. With many people comes many types or genres of film to cater for these people, but the question remains whether people get to, or want to watch a good movie, whether it be mainstream or independent. Some people think that mainstream movies are all society has to offer, liking or used to the mainstream cinema experience but lacking the good movie. A good movie is close to the main reason why neglected groups do not go to the cinema any more, especially women and baby boomers from our parents and grandparents era. Young people are the predominant groups commercialised movies are catered for. Cinemas have to also compete with other forms of viewing a movie, like television, Internet, smart phone and tablet use, DVD and videos. A few but not all innovative ideas should be implemented to keep things under control and maintained and major groups are respected. Some ideas to make cinemas in general more attractive are putting stories, books or publications into movies, movie-dining at cinemas and showing various other movies, like cultural, from time-to-time at mainstream cinemas.

Bibliography

- Alhamraworld.com, 'Effects of Movies on People' – alhamraworld.com/movies/effects-of-movies.html
- Avatar: Making the Movie (November 20, 2012)
- Barnes, Brooks. and Cieply, Michael (February 25, 2011) 'Graying Audience Returns to Movies', <u>The New York Times</u>
- Big Brothers (April 6, 2012) 'Top 10 Most Beautiful & Popular Hollywood Actresses in 2012', GetTopTens.com
- Blurtit.com, 'What is the Influence of Movies on People?', <u>www.blurtit.com/q551252.html</u>
- Bollywood, <u>Wikipedia</u>
- Bowen, Kimberly. 'How to Make a Movie: TopTenReviews', video-editing-software-review.toptenreviews.com/how-to-make-a-movie.html
- Box Office Mojo, All Time Worldwide Box Office Grosses – boxofficemojo.com/alltime/world/
- Bryant, Christina L. (January 5, 2012) 'Audience Demographics: His versus Hers', <u>IndiesUnchained</u> – <u>www.indiesunchained.wordpress.com/2012/01/05/his-and-hers-demos/</u>
- Celebrity, <u>Wikipedia</u>
- Chapati (April 1, 2009) 'The Ugly Side of Fame and Fortune', <u>Yahoo Contributor Network</u>
- Comeondesis.com (January 27, 2009) 'Impact of Movies on Children' – <u>www.comeondesis.com/20090127128/Positive/impact-of-movies-on-children.html</u>
- Darshana A. (January 29, 2009) 'The Impact of Bollywood: An Overview, <u>Yahoo Contributor Network</u>
- Dawn.com (25 October, 2012) 'Bollywood has an immense impact on our lives' – dawn.com/2012/10/25/bollywood-has-an-immense-impact-on-our-lives/
- Erin (23 September, 2002)/Ranu (30 September, 2002)/iulli (16 June, 2003)/ditoman (12 February, 2004)/akhan (12 February, 2004) 'How do Movies or Television influence people's behaviour? Use reasons and specific examples to

- support your answer', Urch.com – www.urch.com/forums/twe/1215-007-how-do-movies-television-influence-people.html
- Federation of Australian Movie Makers (FAMM), (June 1, 2004) About FAMM – www.famm.org.au/about/about.html
- Filmmaking, Wikipedia
- Film Reference.com, 'The film industry and audiences – Spectatorship and Audiences – www.filmreference.com/encyclopedia/Romantic-Comedy-Yugoslavia/Spectatorship-and-Audiences-THE-FILM-INDUSTRY-AND-AUDIENCES.html
- Fulks, Rick. Famous Movie Producers, Lovetoknow.com – Movies - movies.lovetoknow.com/wiki/Famous_Movie_Producers
- Glamsham.com, 'Celebrity Interviews' – www.glamsham.com/movies/interviews/
- Gokulkrishnan, R.C. (June 14, 2007) 'Influence of Cinema on Society', Shvoong – www.shvoong.com/humanities/1618397-influence-cinema-society/
- Guardian.co.uk, The World's 40 Best Directors – film.guardian.co.uk/features/page/0,11456,1082823,00.html
- HBO Europe, Hollywood Best Film Directors – www.hbfd.info
- Lorettaanne (July 12, 2011)/mwestwood (July 12, 2011)/akannan (July 12, 2011)/pohnpei397 (July 13, 2011)/accessteacher (July 13, 2011)/herappleness (July 13, 2011)/wannam (July 14, 2011)/brettd (July 14, 2011)/kiwi (July 16, 2011), 'Do Films Influence Society or does Society Influence Films?', Endnotes.com, www.endnotes.com/cinema/discuss/do-films-influence-society-does-society-influ-96895
- Mohan, Rohini (June 1, 2011) 'Movies and Their Impact on Society', Buzzle – www.buzzle.com/articles/movies-and-their-impact-on-society.html

- Morgan, Kim. 'When Young Stars Burn Out', <u>MSN Movies News</u> – movies.msn.com/movies/article.aspx?news=132731
- Moviefone.com (24 July, 2012) 'Can Movie Theatres Win Back Grown-Up Audiences' – news.moviefone.com/2012/07/18/adult-movie-audiences-demographics_n_1684755.html
- Movie Star, <u>Wikipedia</u>
- Museum of the City, 'Bollywood Influence on lives of Indian people' – www.museumofthecity.org/exhibit/bollywood-influence-lives-indian-people
- Nielsen Wire (October 6, 2008) 'Movie Marketers, Meet Your Ideal Audience' – blog.nielsen.com/nielsenwire/tag/movie-audience-demographics/
- NJNJ.ru (2008-2009) 'Topic 7: How do movies or TV affect people?' – njnj.ru/essay/shtml/movies_influence.shtml
- Reisman, David & Evelyn T. (Autumn, 1952) 'Movies and Audiences', <u>JSTOR: American Quarterly</u>, Vol. 4, No. 3, pp. 195-202.
- Rihan (30 September, 2010) 'Top Most Expensive Actresses in Hollywood', www.listal.com
- Ross, Scott. (29 February, 2012) 'Fame, Fortune and Other Foolishness', <u>CBN.com</u> – blogs.cbn.com/ScottRoss/archive/ 2012/02/29/fame-fortune-and-other-foolishness.aspx
- SAWA 'Demographics of the Cinema Audience' – www.sawa.com/resources/audience
- Screen Producers Association of Australia (SPAA), What We Do & Member Profiles – <u>www.spaa.org.au</u>
- Squidoo.com '37 Most Famous Hollywood Actors' – www.squidoo.com
- Statista, 'Statistics and Facts about the Film Industry' – www.statista.com/topics/964/film/
- Studentnet.edu.au, 'Making a Movie: Visual Literacy, How do I make meaning' –

portals.studentnet.edu.au/literacy/Ministeries/SCEGGSDarlinghurstrevised/vliteracy/meaning.html
- Swaim, Michael. (November 30, 2012) '5 things You Should Know Before Making an Indie Movie', Cracked.com – www.cracked.com/blog/5-things-you-should-know-before-making-indie-movie/
- The New Yorker (25 June, 2012) 'Ben Stiller, Walter Mitty and the Dilemma of Modern Stardom'
- United Nations Educational, Scientific and Cultural Organization (UNESCO) Institute for Statistics (February 2012), 'Cinema Statistics': UIS Information Bulletin No.8 – From International Blockbusters to National Hits, Analysis of the 2010 UIS Survey on Feature Film Statistics/Analysis of 2007 UIS Statistics on Feature Films (2009)

www.ingramcontent.com/pod-product-compliance
Lightning Source LLC
Chambersburg PA
CBHW080527190526
45169CB00008B/3080